G000299099

Wisteria Doorway

This colourful study captures two contrasting details: the strong shape of the steps and the white railings, softened by the flow and 'froth' of the violet-blue wisteria plant. The deep shadows highlight the contrast and add depth to the scene.

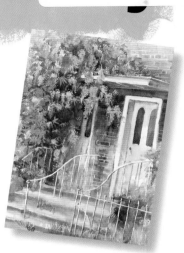

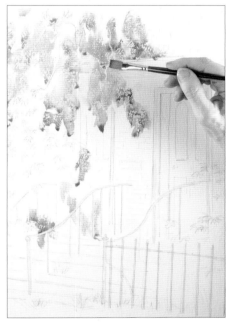

1 Use a ruling pen to apply masking fluid to the door frame, fence, flowers, grasses and railings as shown.

2 Wet the whole flower area with clean water and use the 10mm (³/₈in) flat brush to paint the wisteria with a mix of cerulean blue and permanent rose. Make the mix pinker in places and bluer in others. Drop in cobalt blue wet into wet in places.

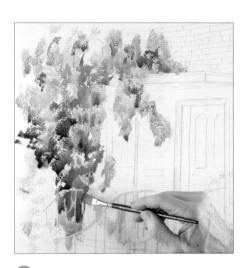

3 Mix olive green with a little of the flower colour and paint foliage between the flowers. Add Winsor blue to the mix for some darker foliage.

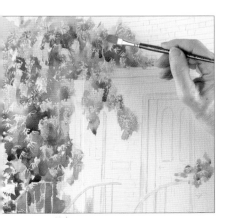

4 Add some yellow ochre at the top.

5 Mix olive green and yellow ochre to paint the greenery on the right-hand side and the path in the foreground. Use Winsor blue mixed with olive green for the darker parts.

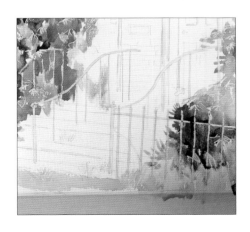

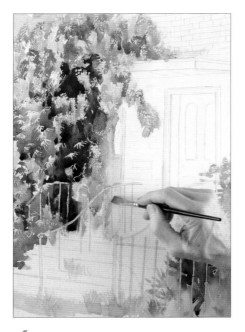

6 Add more dark green on the left, with a little more Winsor blue in it. Paint between the railings and fade off the edges.

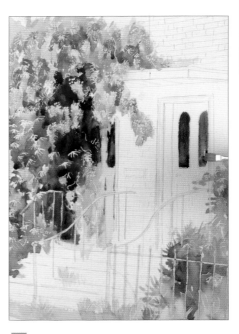

7 Mix raw umber and Winsor blue to paint the dark parts of the half-hidden door on the left, and the dark parts of the main door.

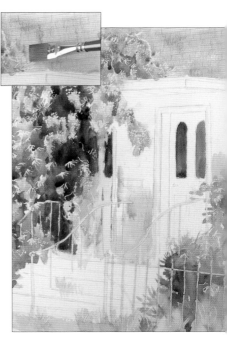

8 Wet the whole brickwork area with clean water. Use the 20mm (¾ in) flat brush to paint burnt sienna over the bricks, then drop in cadmium orange in places.

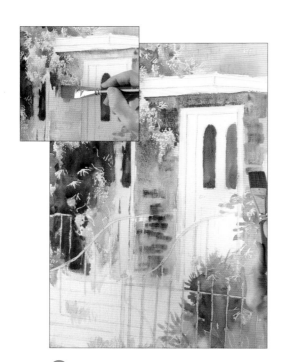

9 Paint around the door with burnt sienna, then mix in cobalt blue and add darker touches.

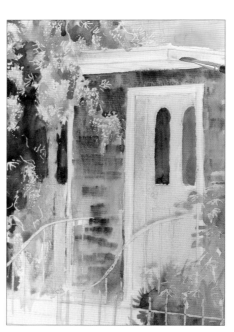

10 Paint a thin wash of cerulean blue on the door, the half-hidden door on the left and the top of the porch.

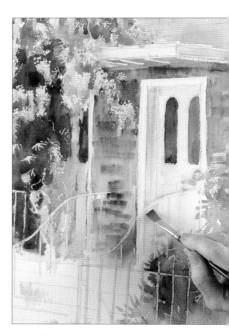

11 Paint burnt sienna on to the shadowed underside of the porch. then drop yellow ochre into the shadowed parts of the door.

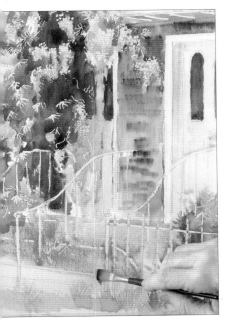

12 Wet the steps and paint them with a thin wash of Davy's gray with a little burnt sienna.

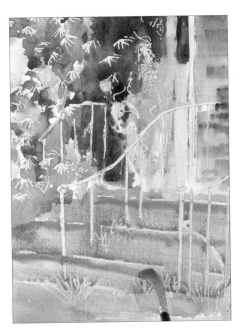

13 Paint a line of Davy's gray wet into wet beneath each masked out line to create shadow.

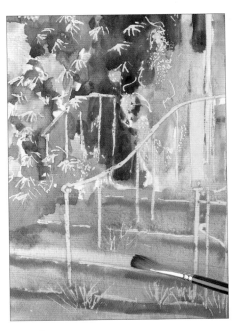

14 Wash and blot dry the brush and lift off paint on the flat part of the steps.

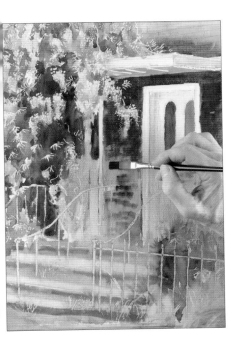

15 Paint a warm area of burnt sienna above the porch. Then add raw umber and paint the darker area under the porch.

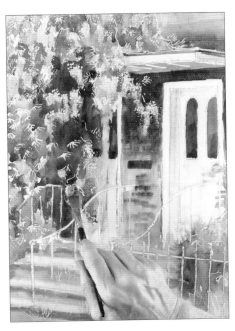

16 Use a dark mix of burnt sienna and cobalt blue to paint the letter box in the brickwork to the left of the door and the shade behind the railings.

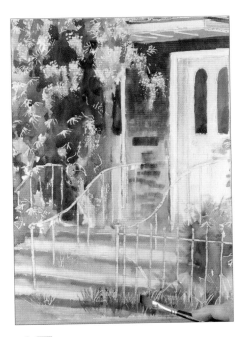

17 Mix olive green and a little Winsor blue to paint the masked out grasses in the foreground.

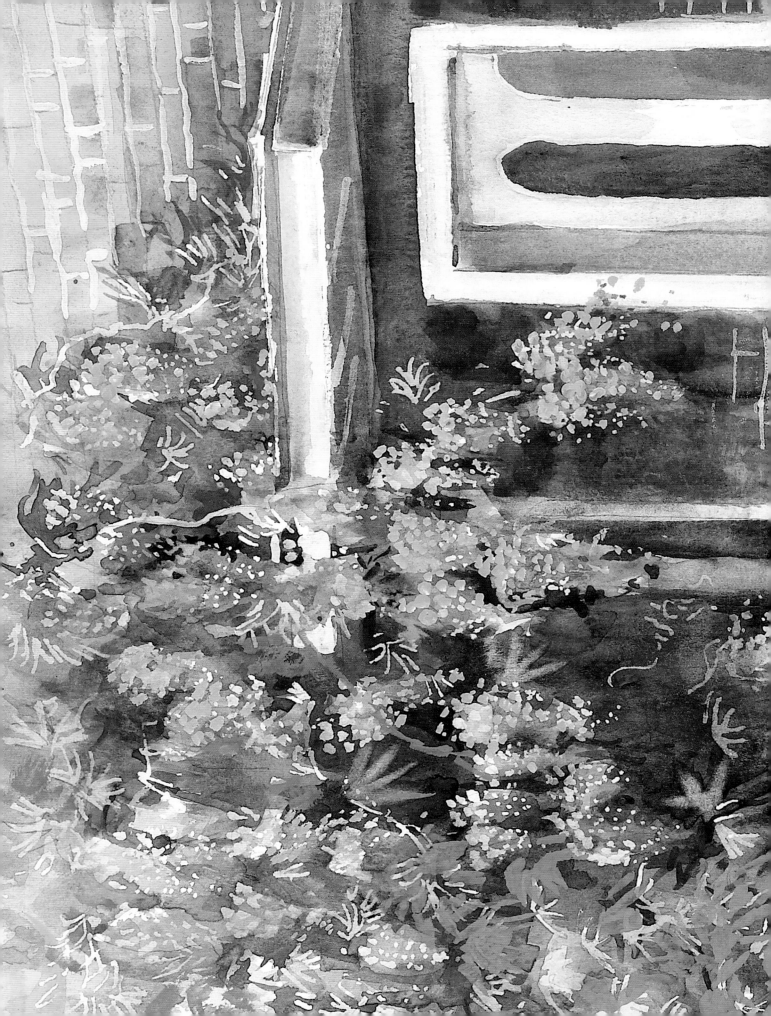

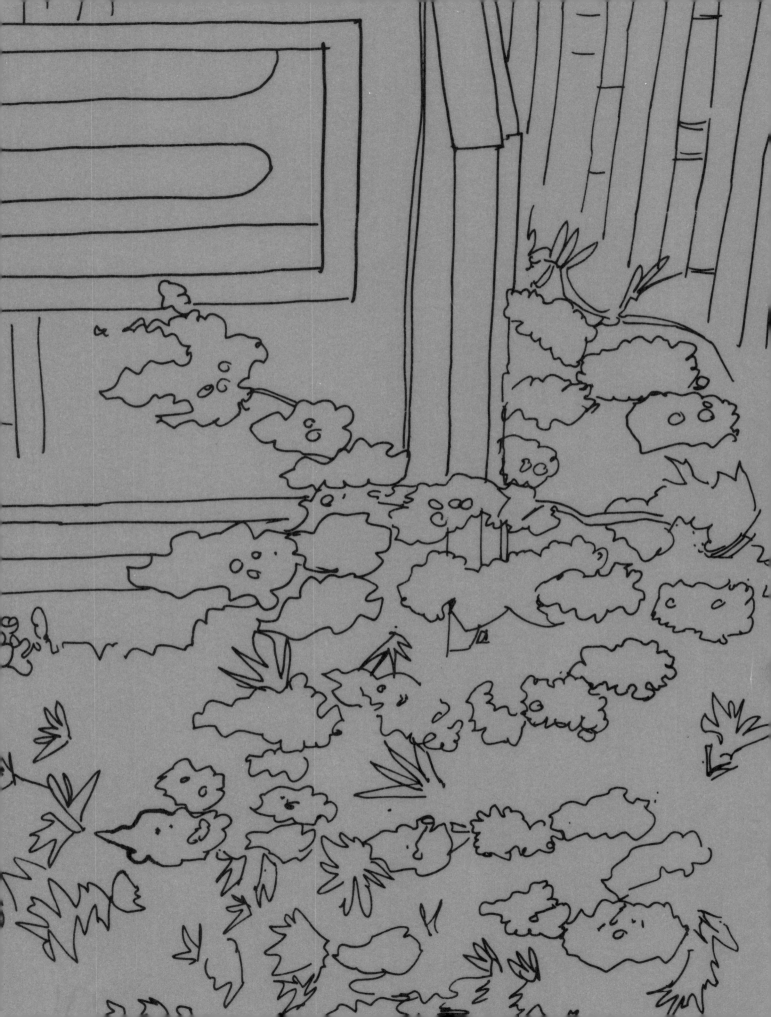

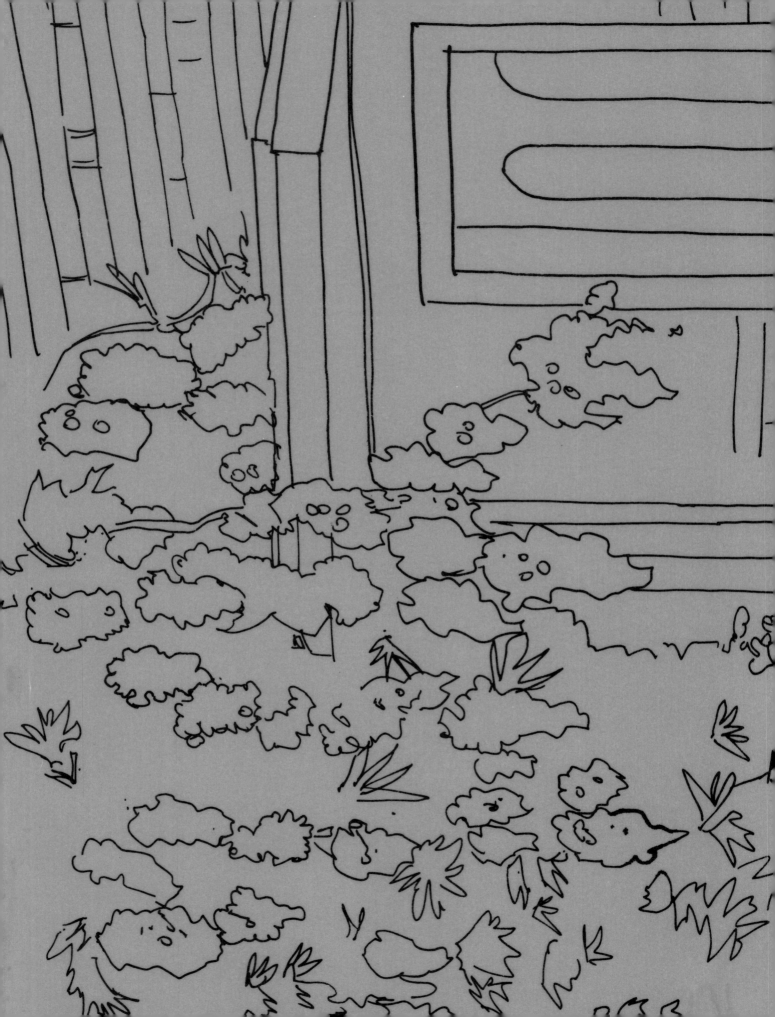

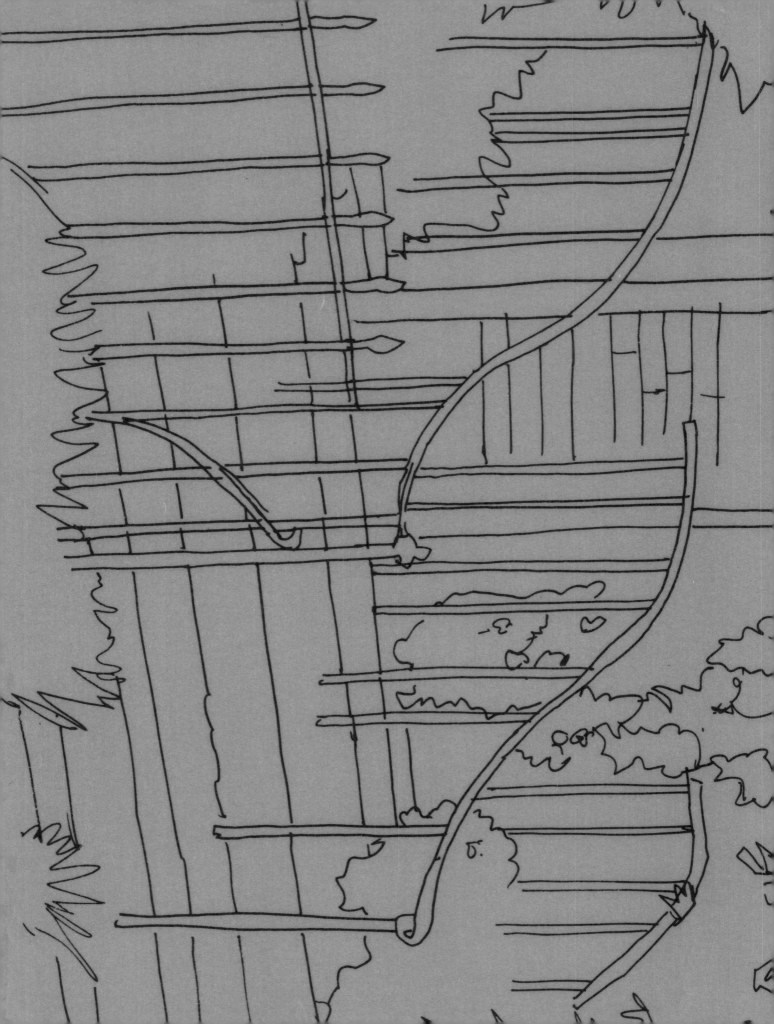

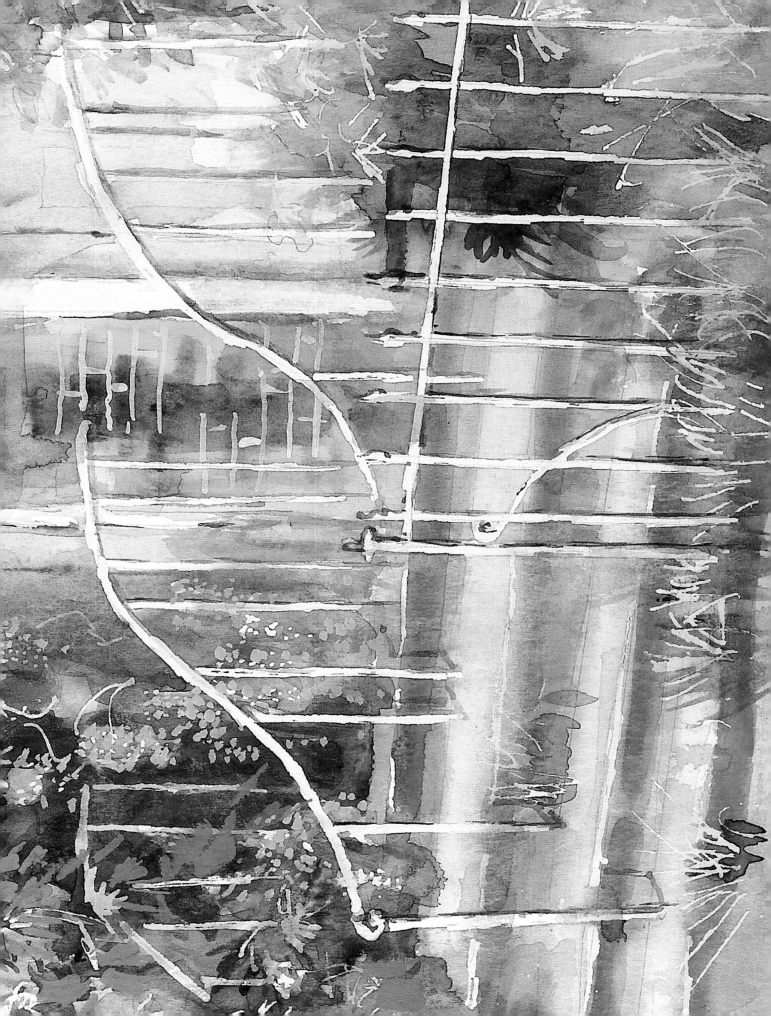

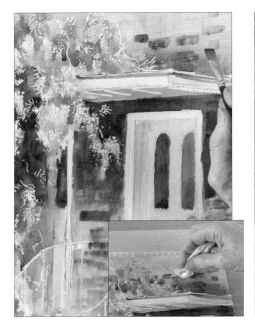

18 Paint brick shapes with burnt sienna and raw umber, and use a paper tissue to lift out colour for a natural, weathered look.

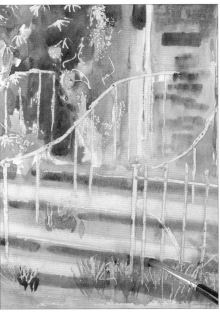

19 Change to the 10mm (³/₈in) brush. Paint over the shadow on the steps with cobalt blue.

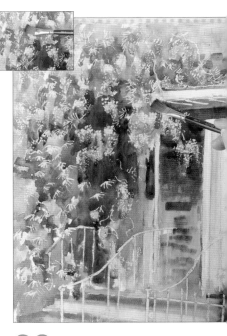

20 Add cobalt blue and then more permanent rose to the wisteria flowers.

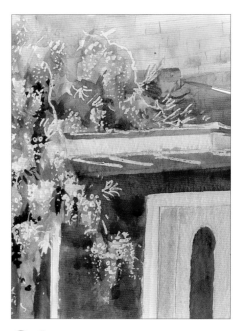

21 Use the rigger brush to paint trails of dark foliage between the flowers with Winsor blue mixed with olive green.

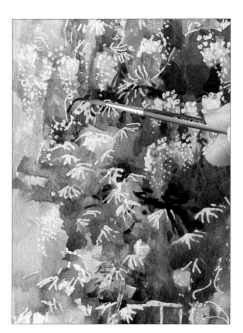

22 Use Winsor blue to paint dark areas in the wisteria, bringing out the shape of the flowers.

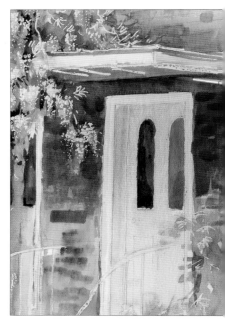

23 Still using Winsor blue, darken the window in the door and under the porch.

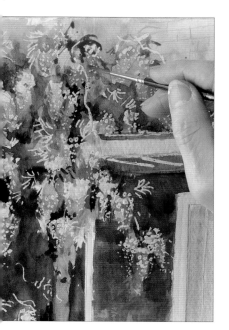

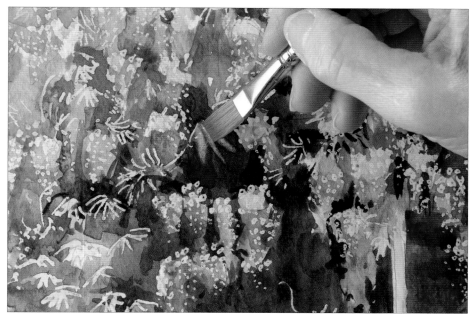

24 Still using the rigger, paint ark tendrils at the top of the painting ith olive green.

25 Change to the 10mm (³/₈in) flat brush and lift out details from the dark areas between the foliage. Allow to dry.

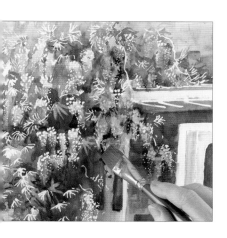

26 Rub off all the masking fluid. Paint a wash of permanent rose over the wisteria.

27 Add cerulean blue to the permanent rose and wash it over the darker parts of the wisteria.

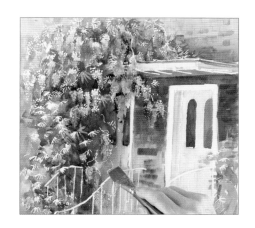

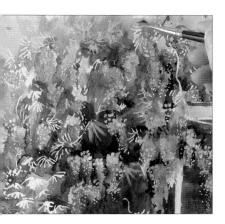

28 Wash yellow ochre over arts of the foliage at the top of e painting.

29 Mix cerulean blue with a little cadmium yellow and wash this over some areas of the foliage.

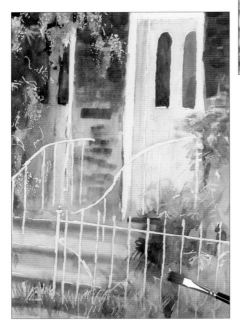

30 Paint over the foliage on the right with olive green and then cadmium yellow.

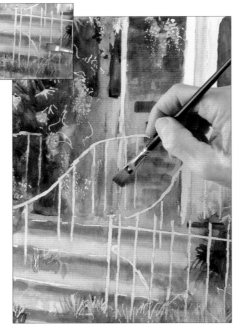

31 Use yellow ochre on the vertical parts of the steps and on the half-concealed door on the left.

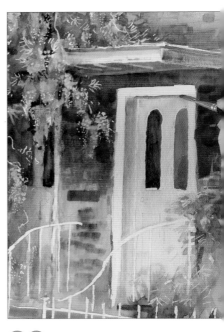

32 Use cobalt blue to add shadow to the white parts of the porch and the door.

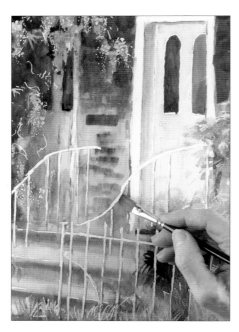

33 Add cobalt blue shadow to the railings.

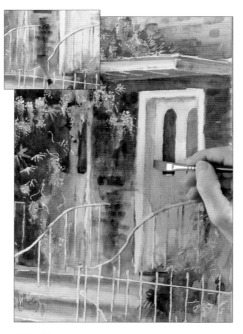

34 Paint dappled shadow on the wall, still using cobalt blue, then use a diluted wash to shade the door.

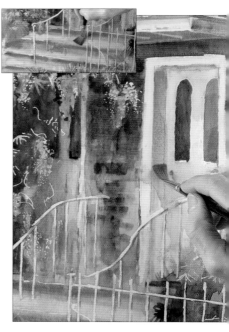

35 Strengthen the yellow ochre shadows on the steps and door.